Cute Corgis Coloring Book For Adults

This Corgi Coloring book belongs to:

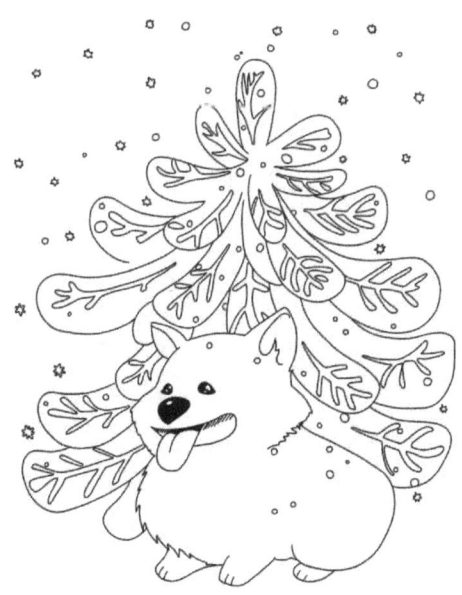

Copyright © 2019 Adult Coloring Books

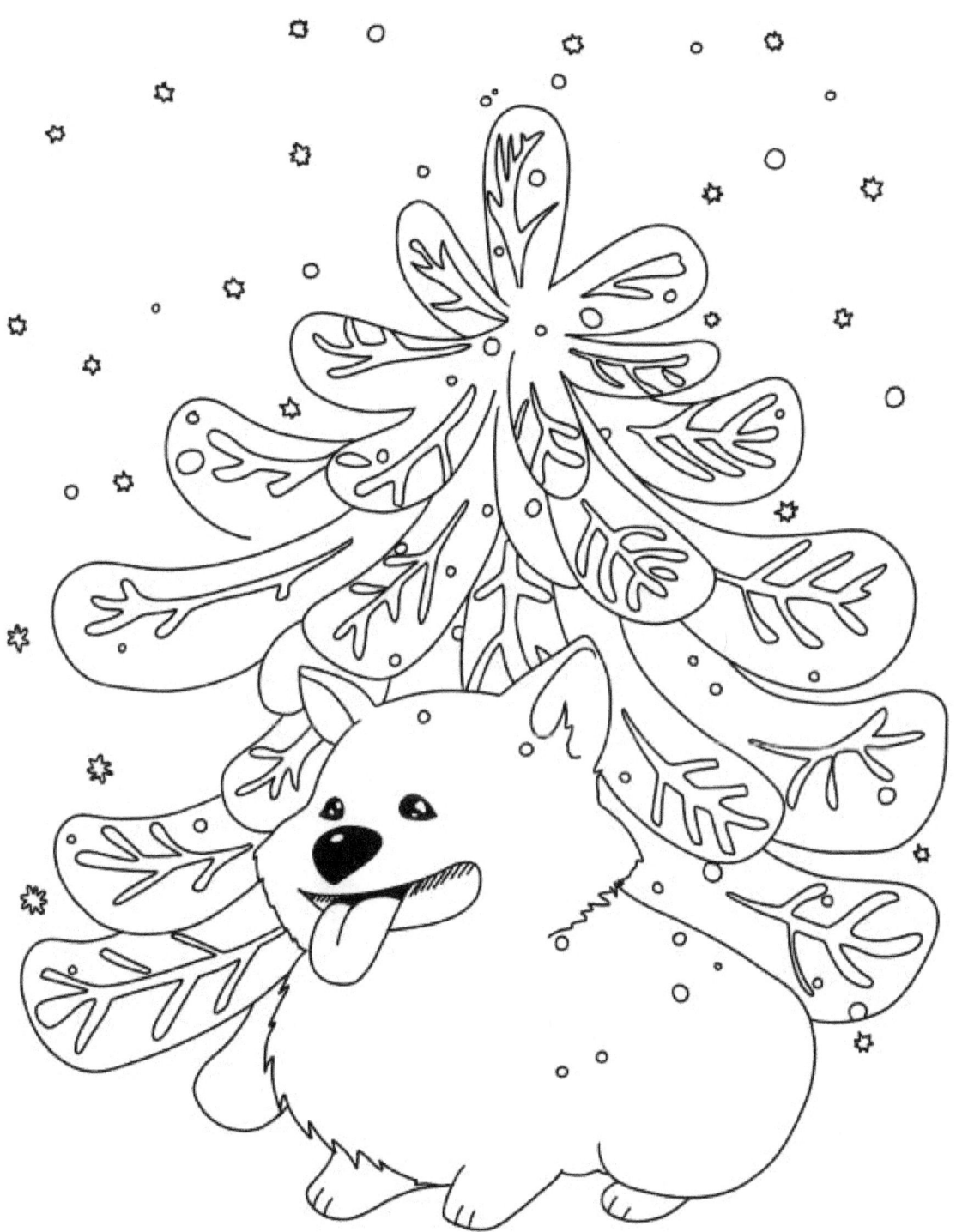

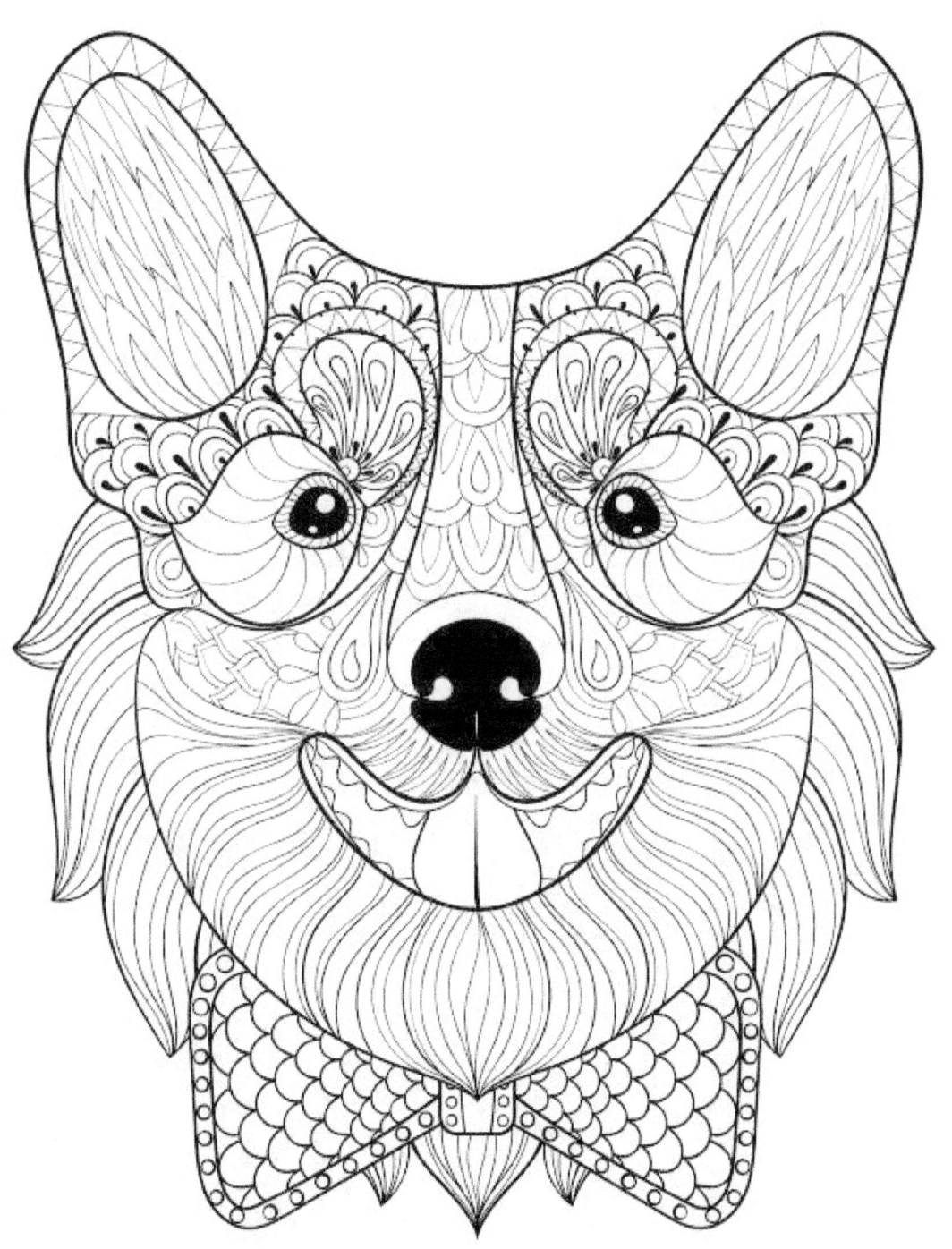

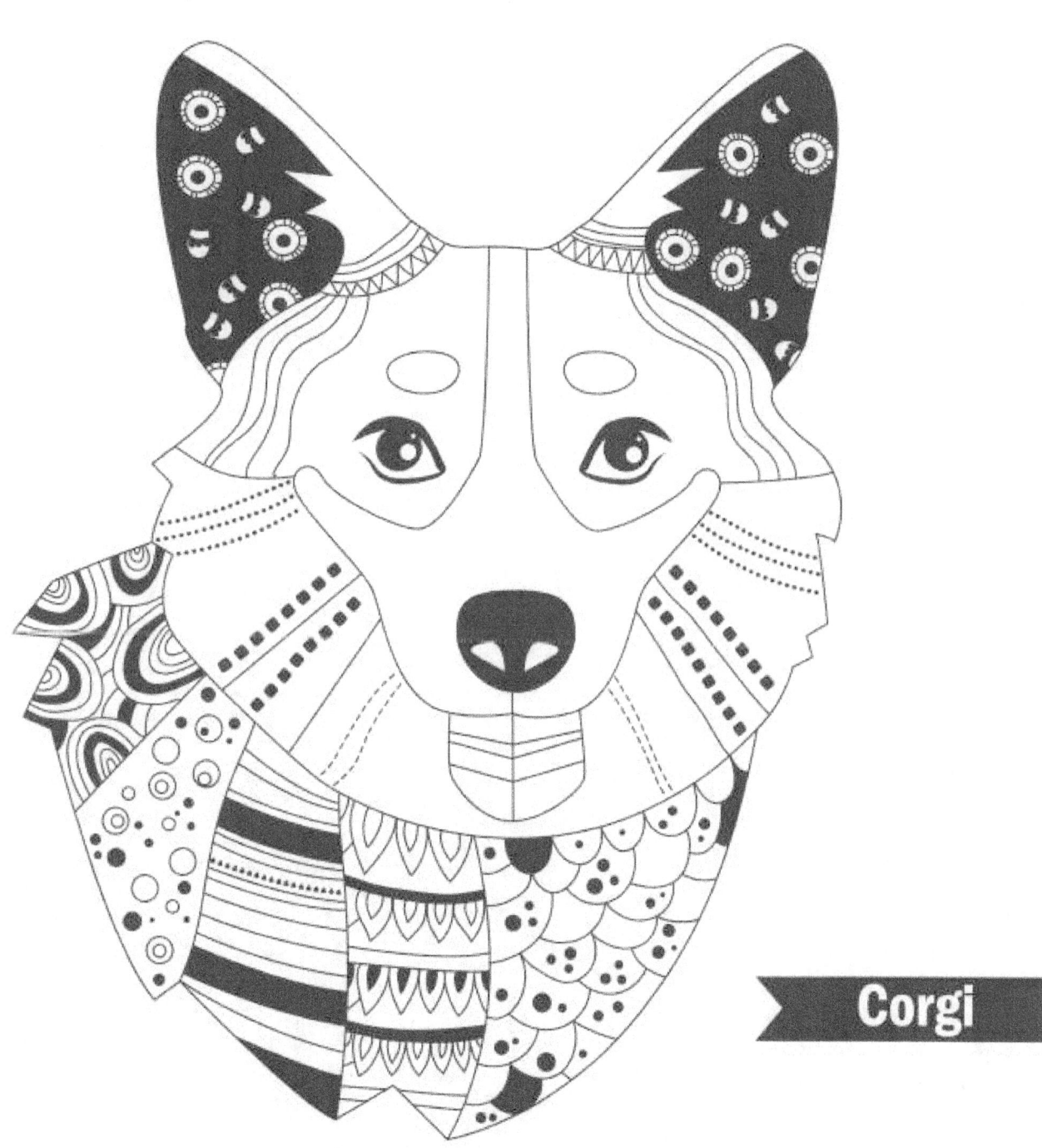

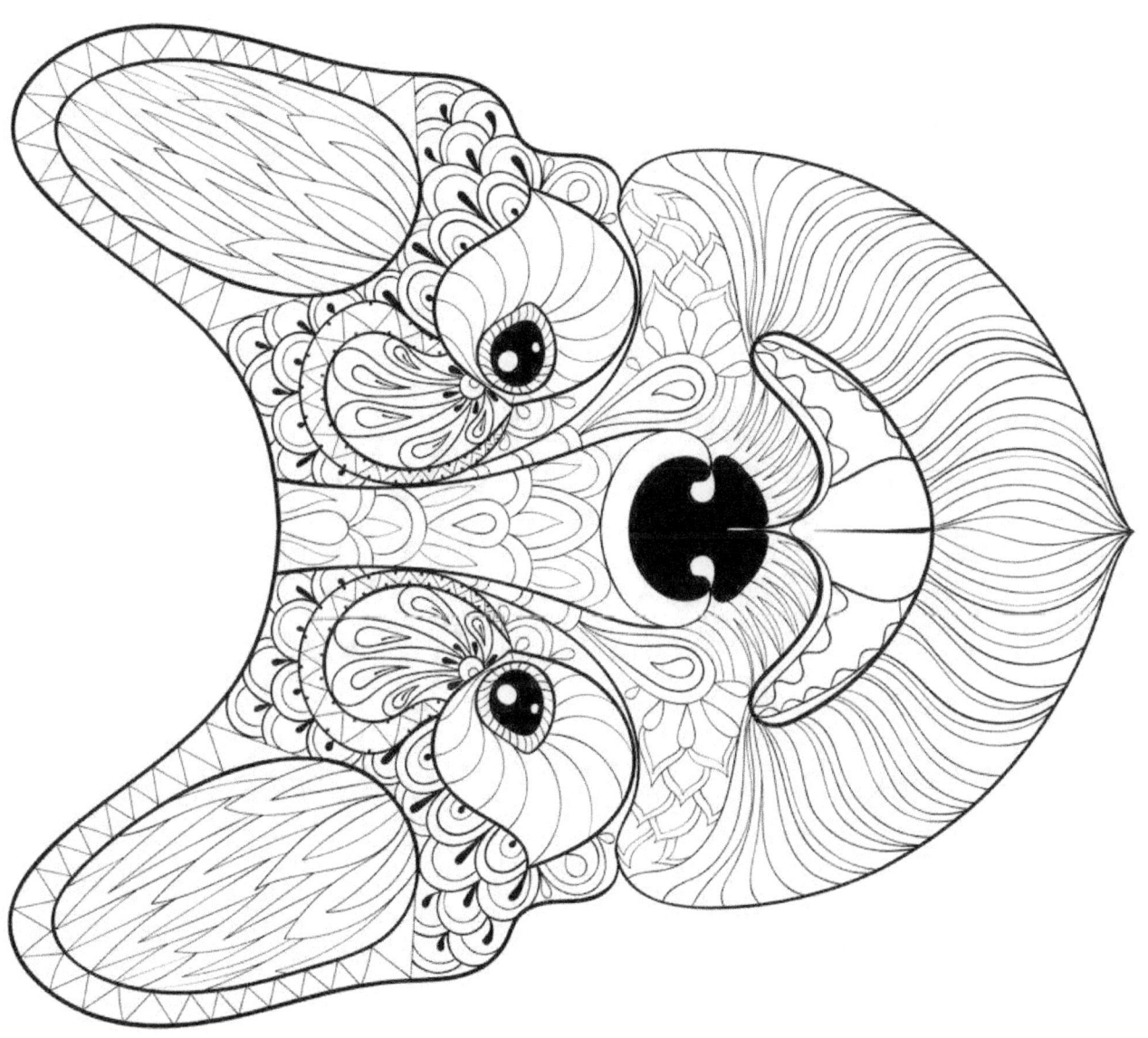

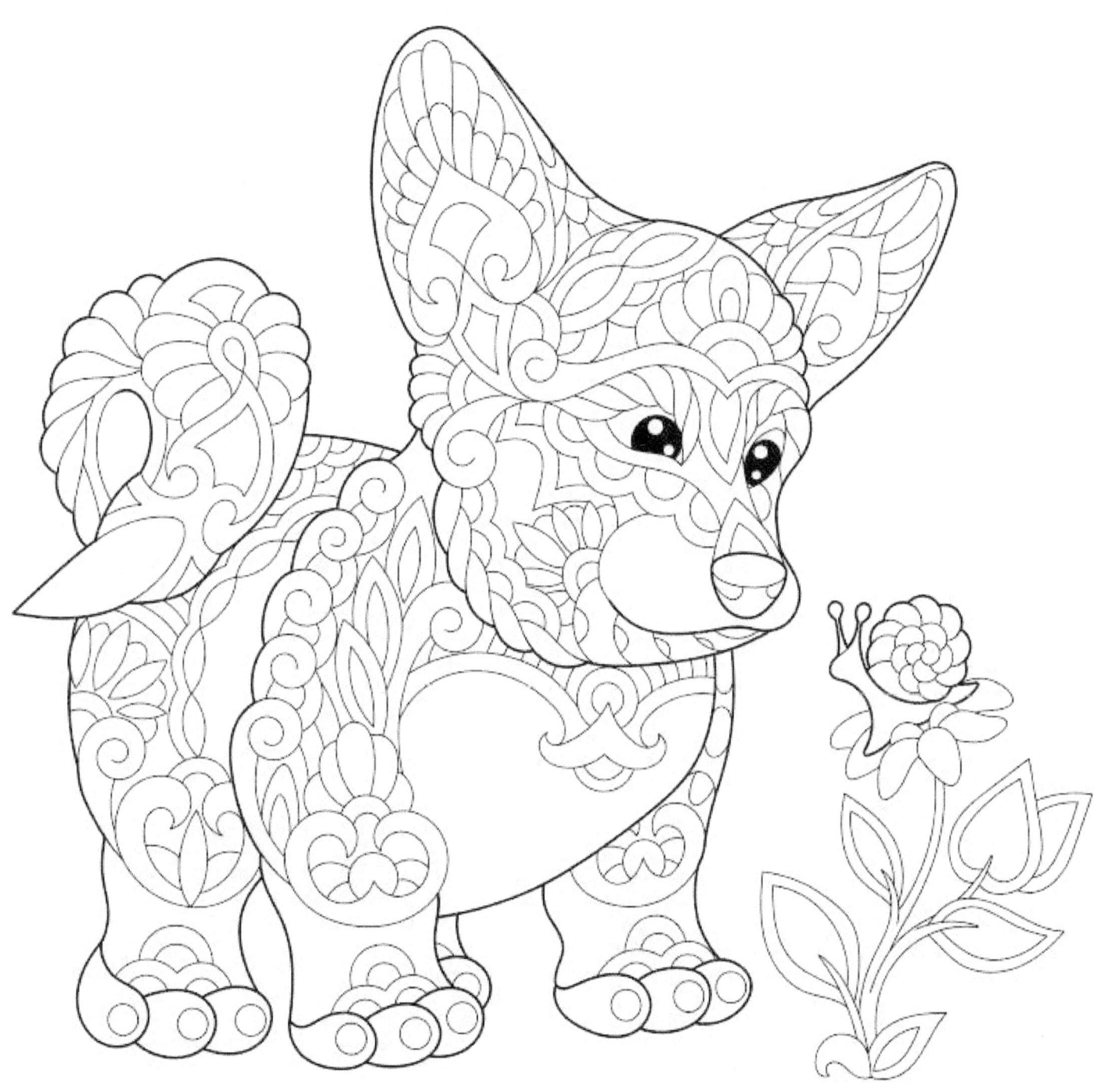

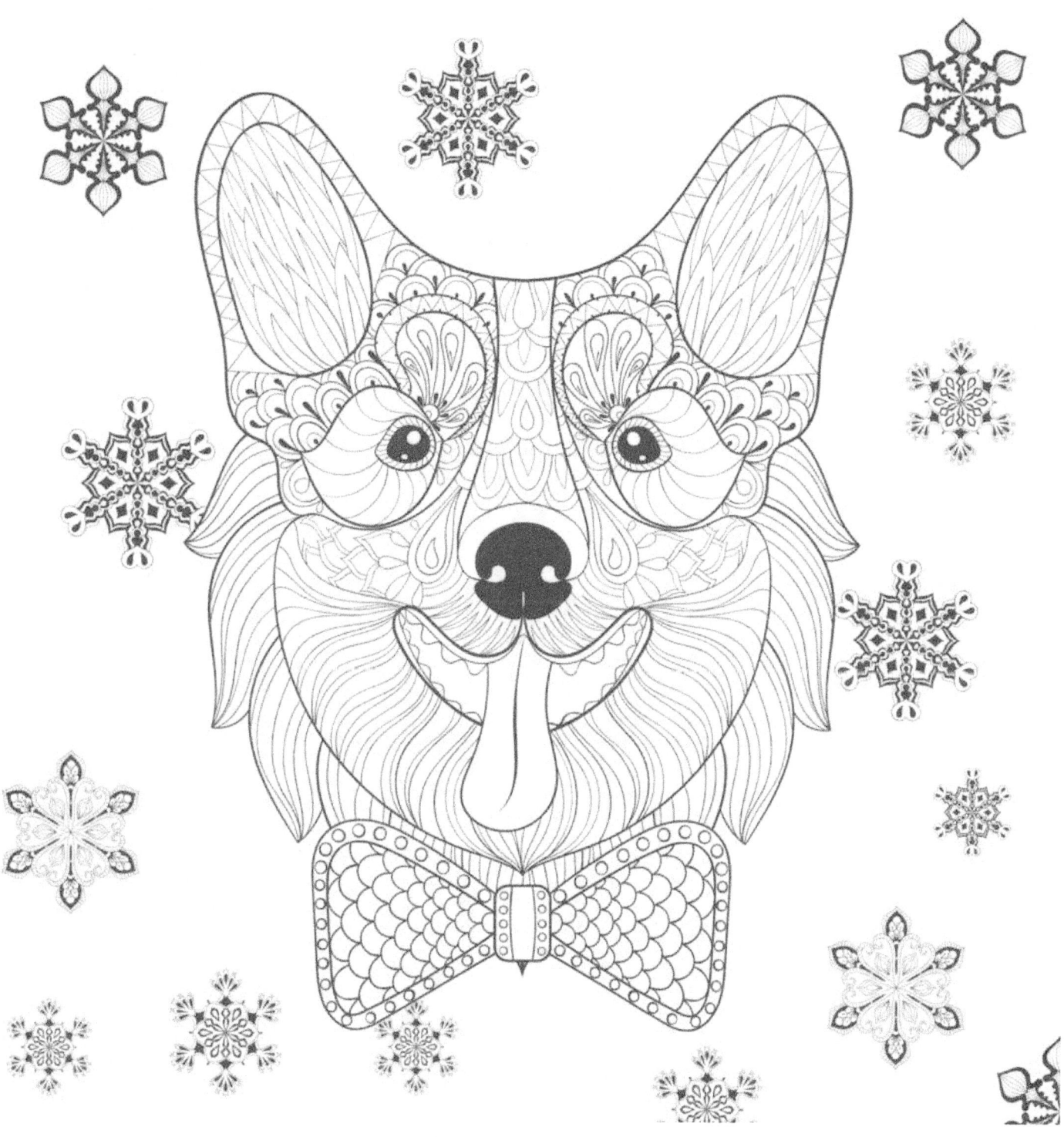

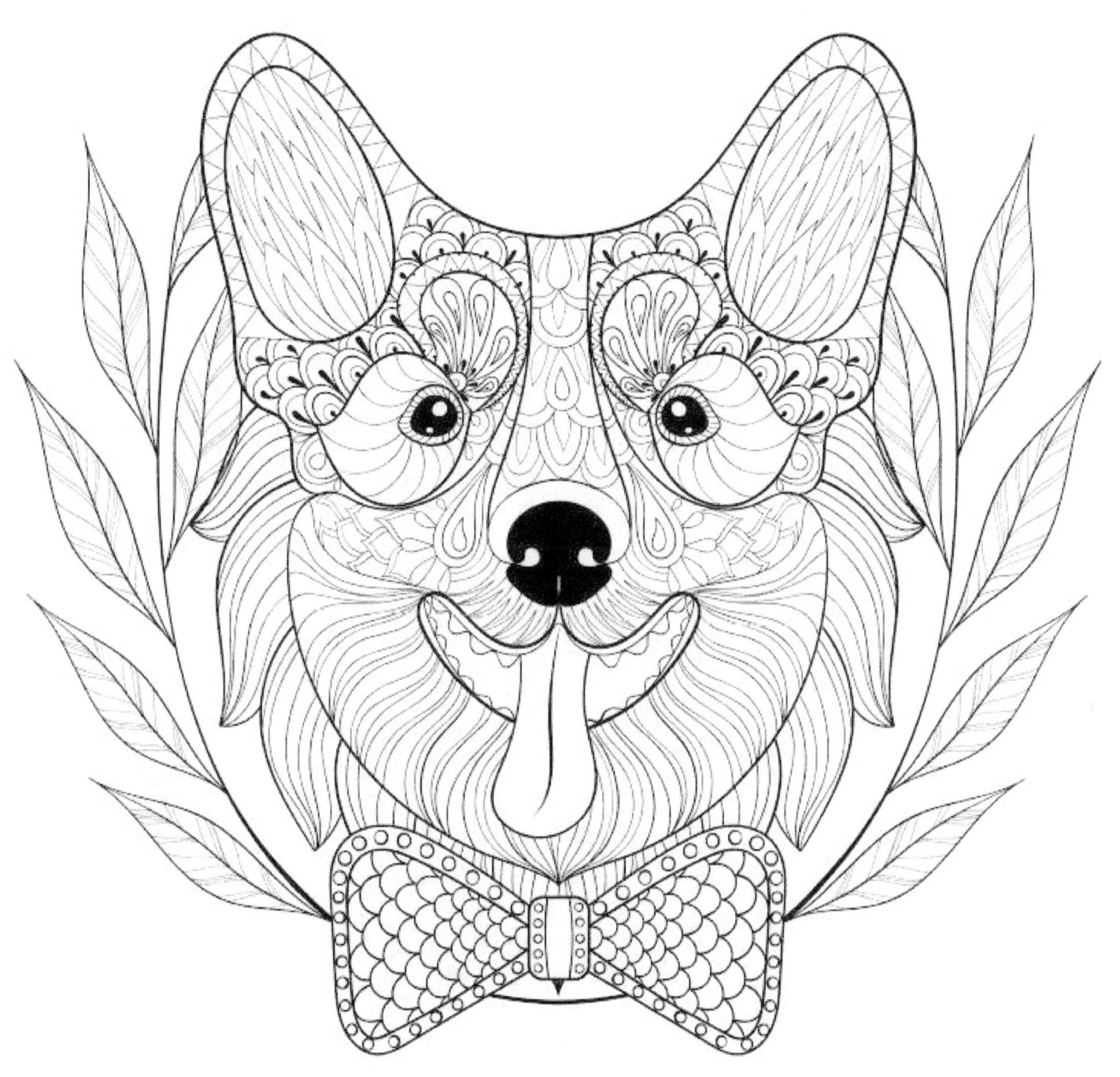

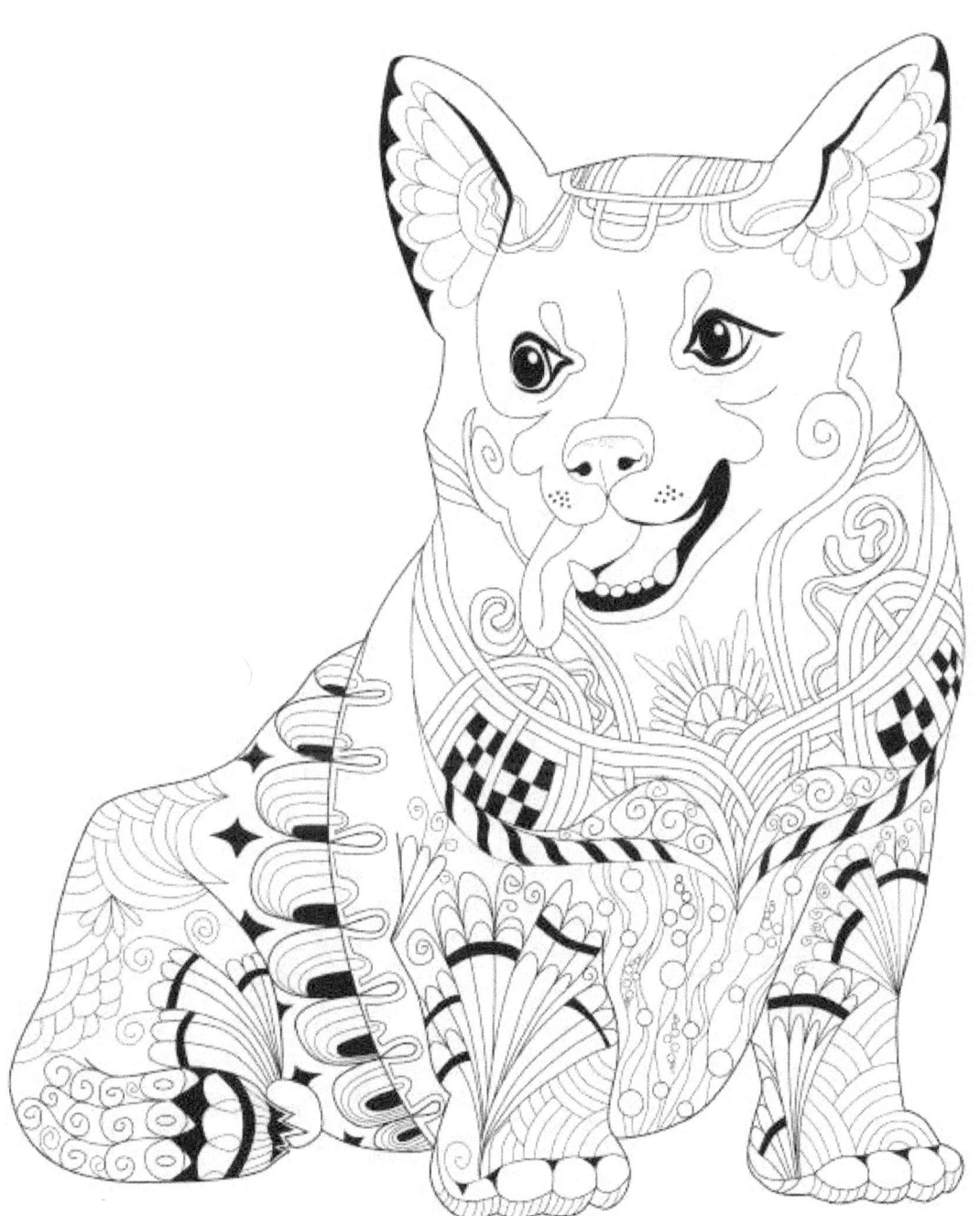

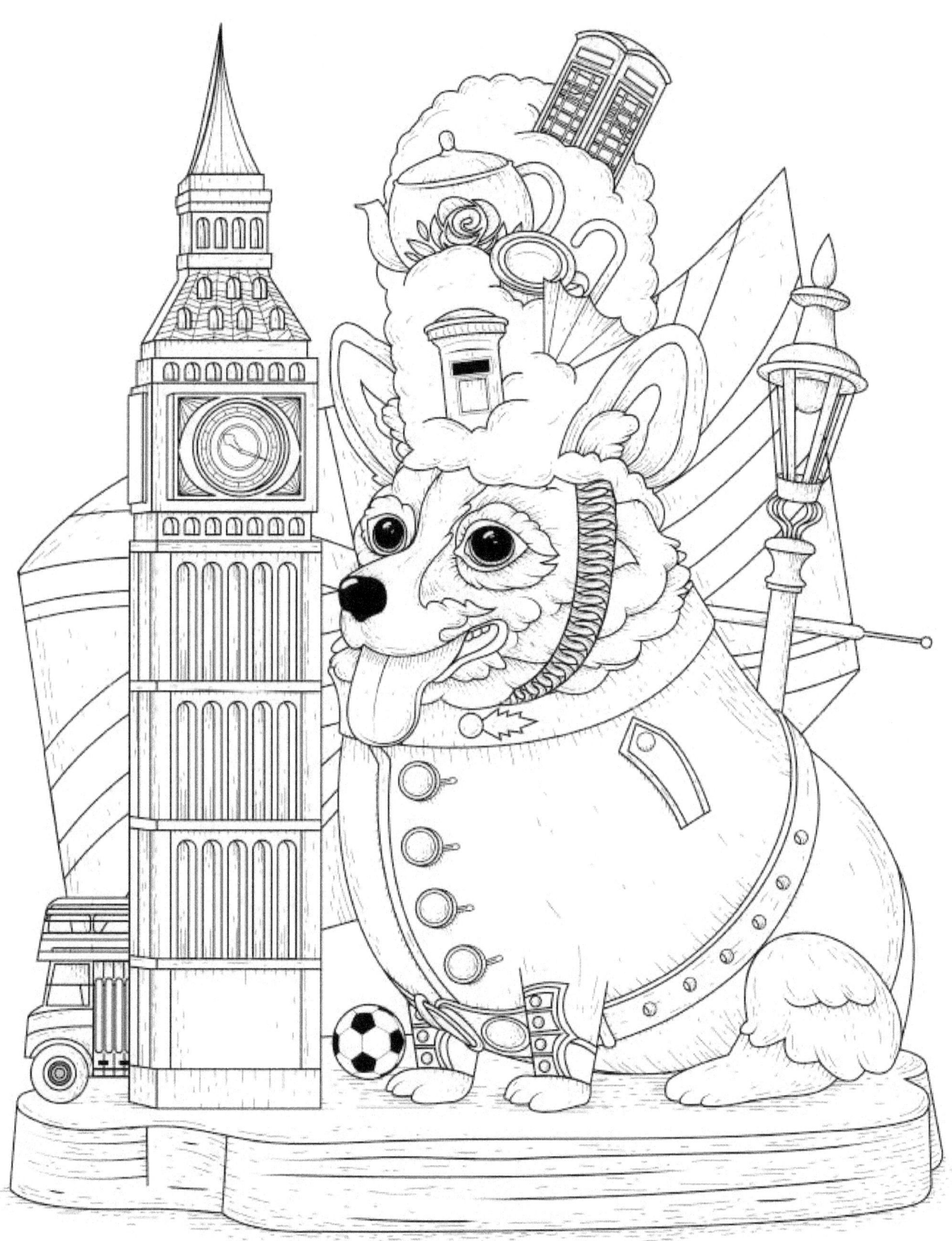

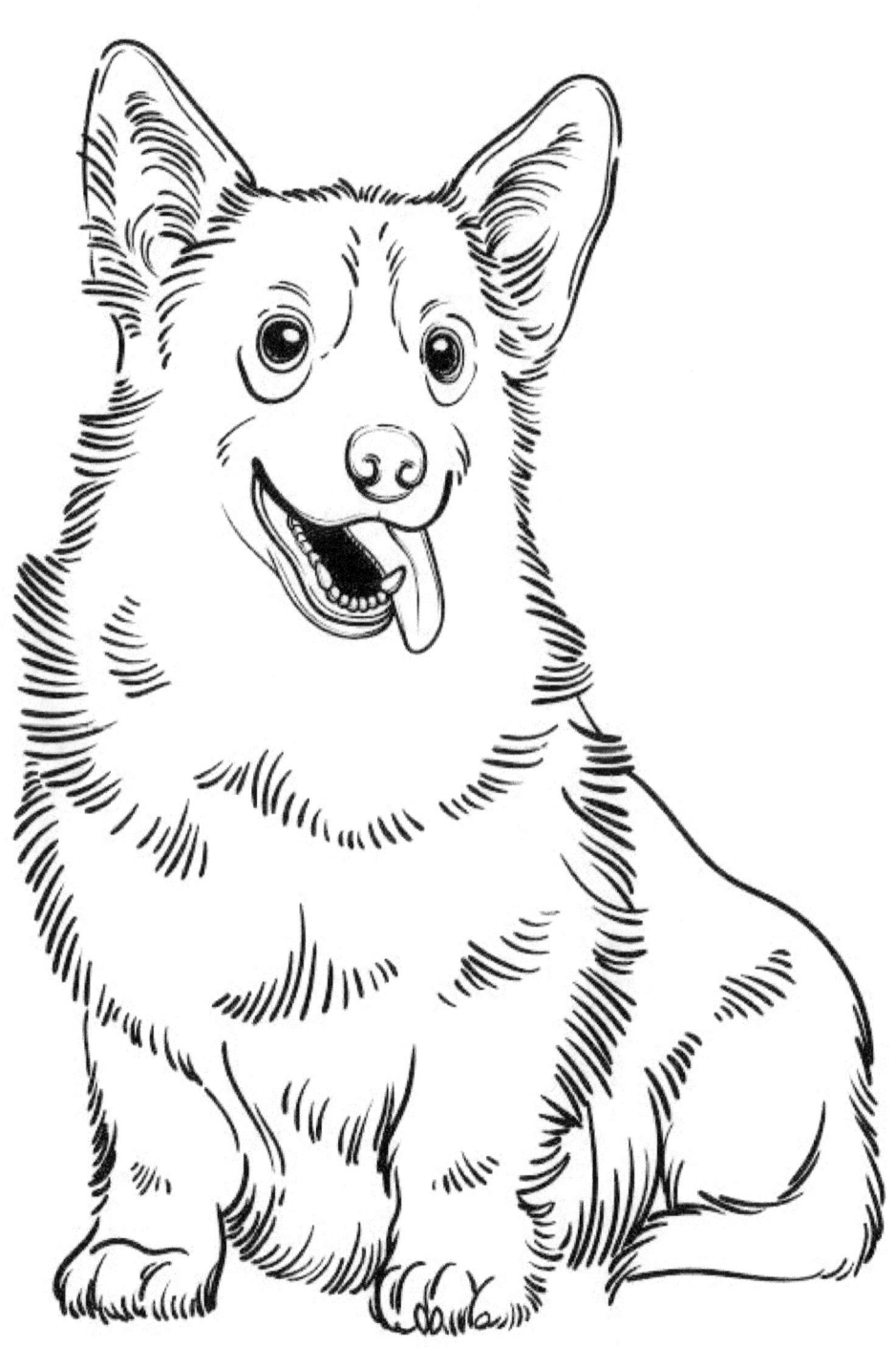

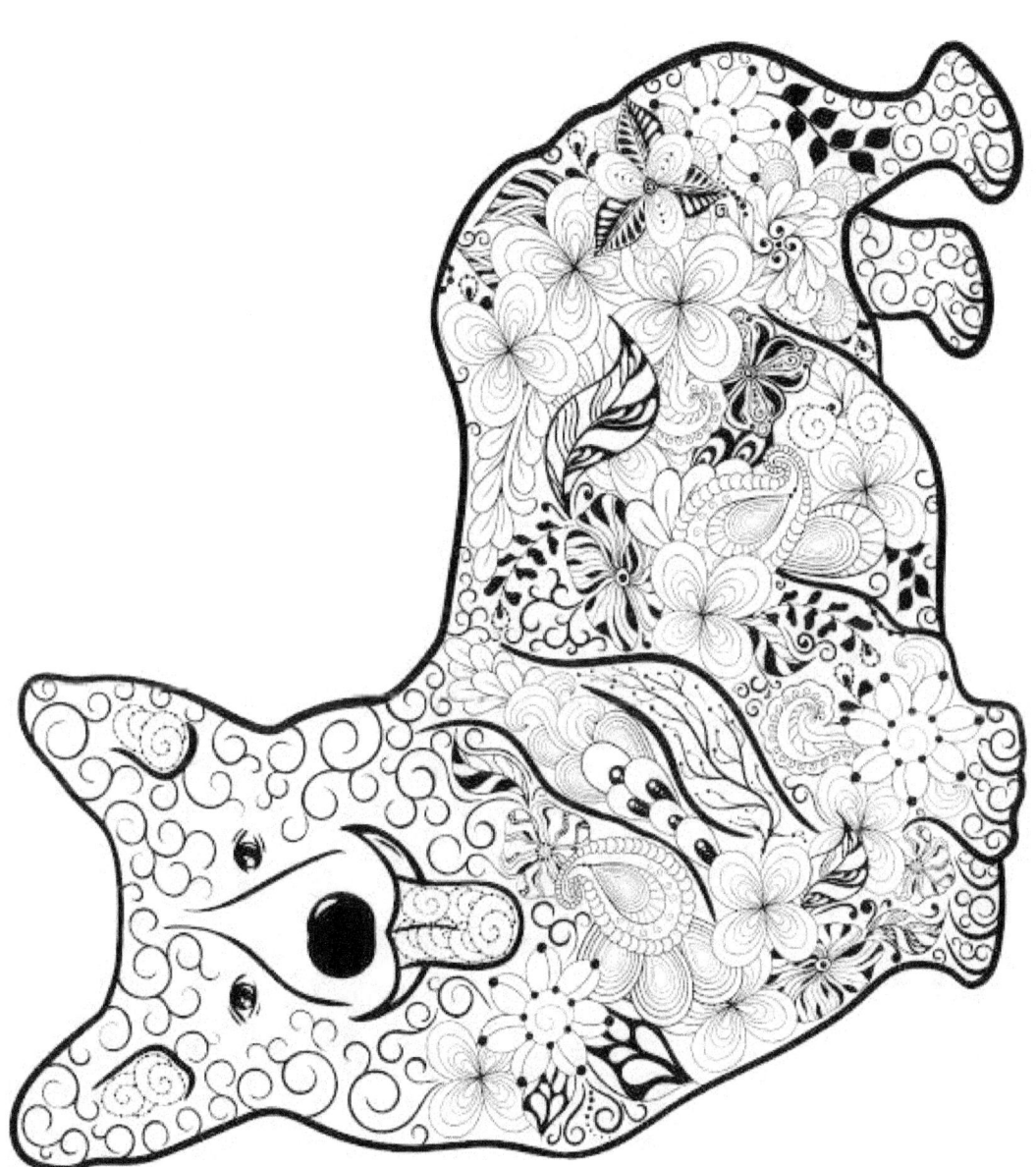

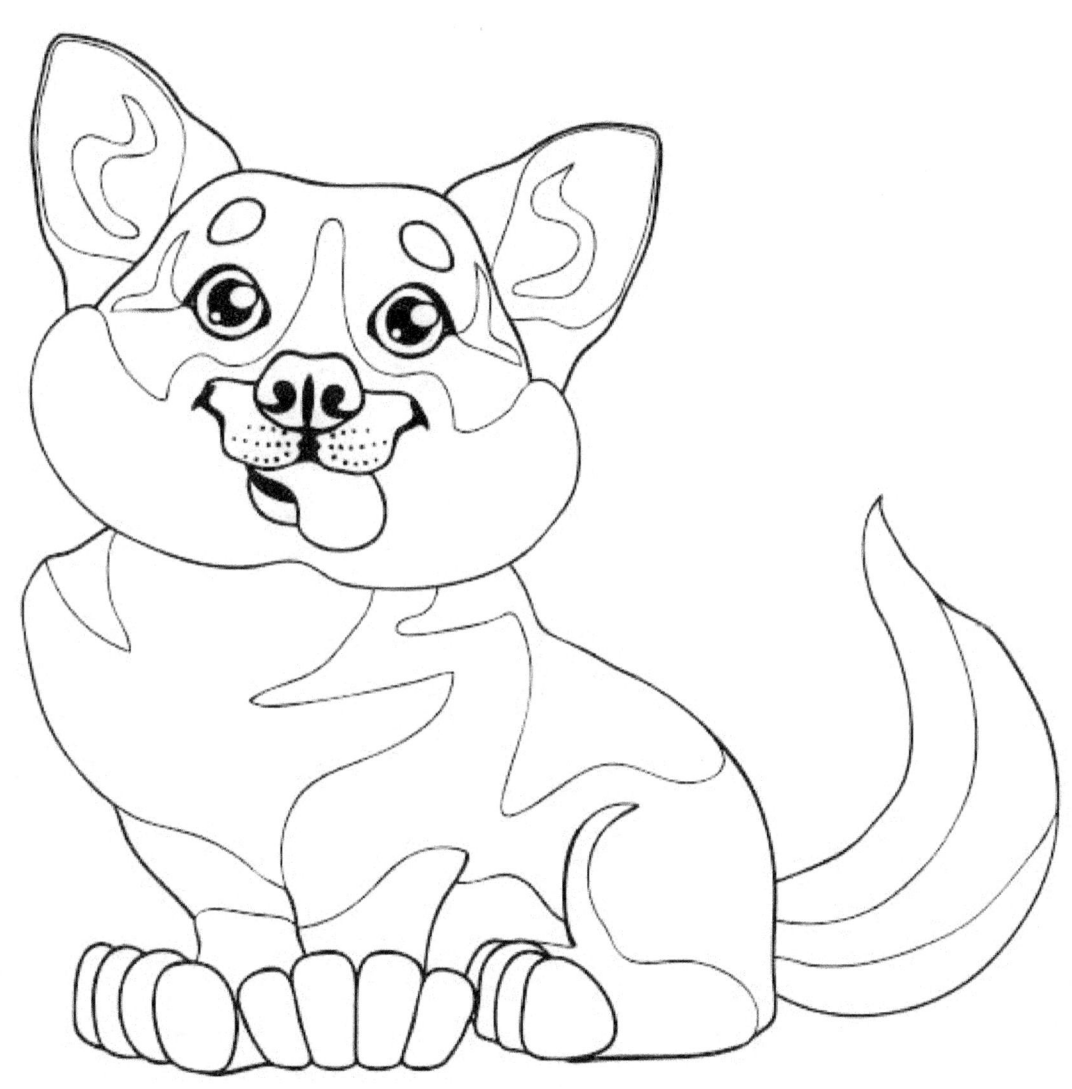

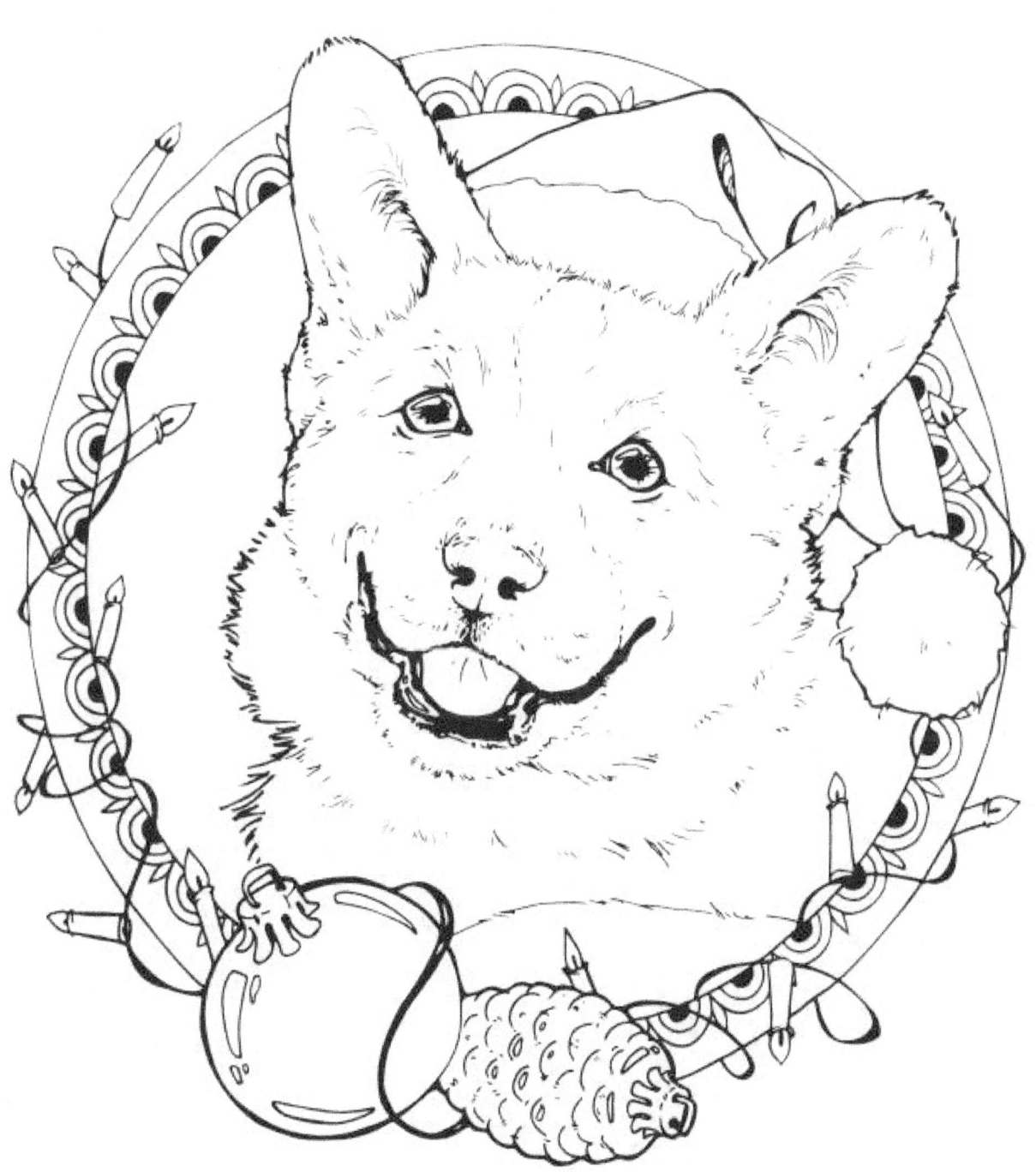

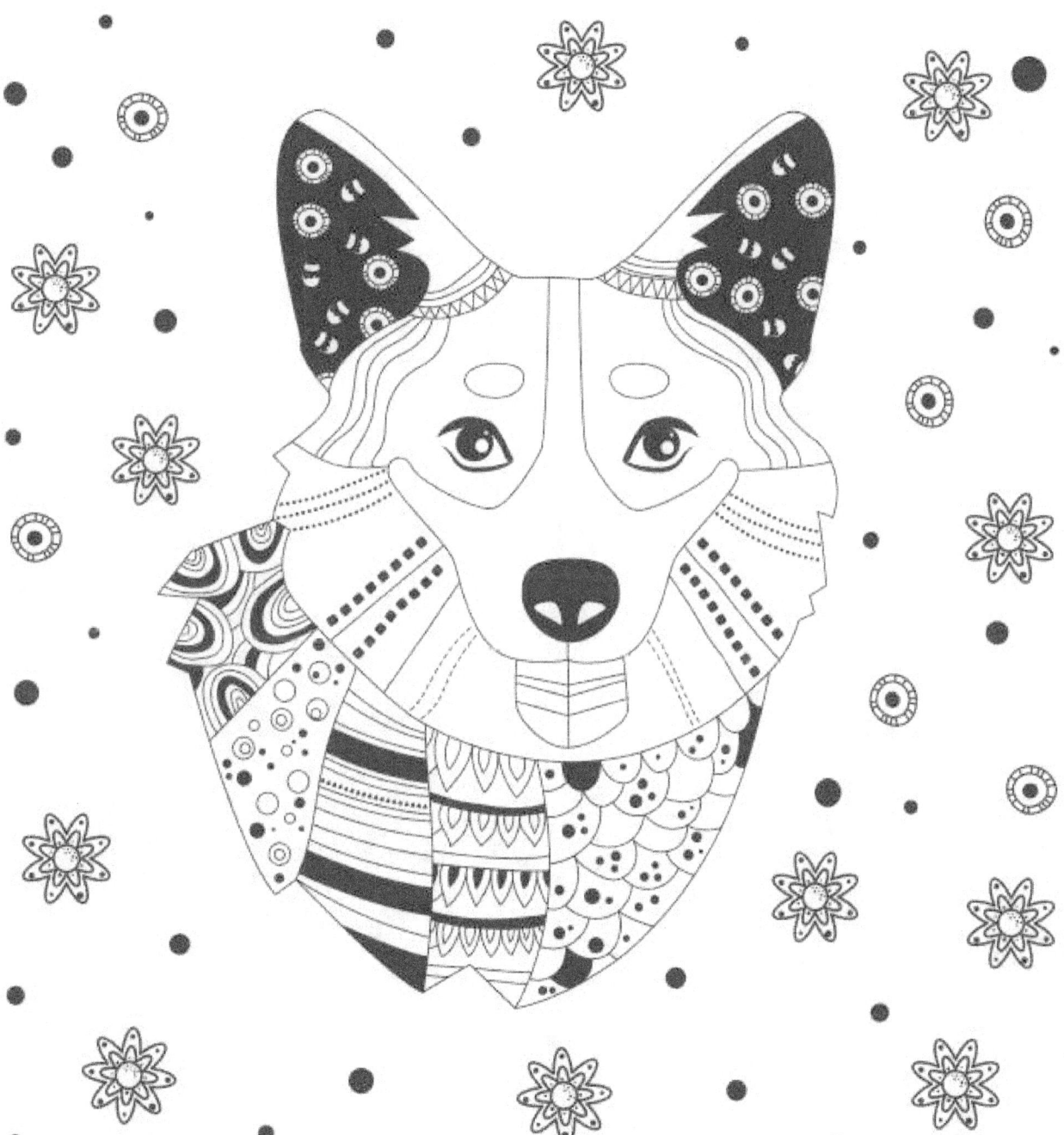

BONUS CORGI DOT TO DOT PUZZLES

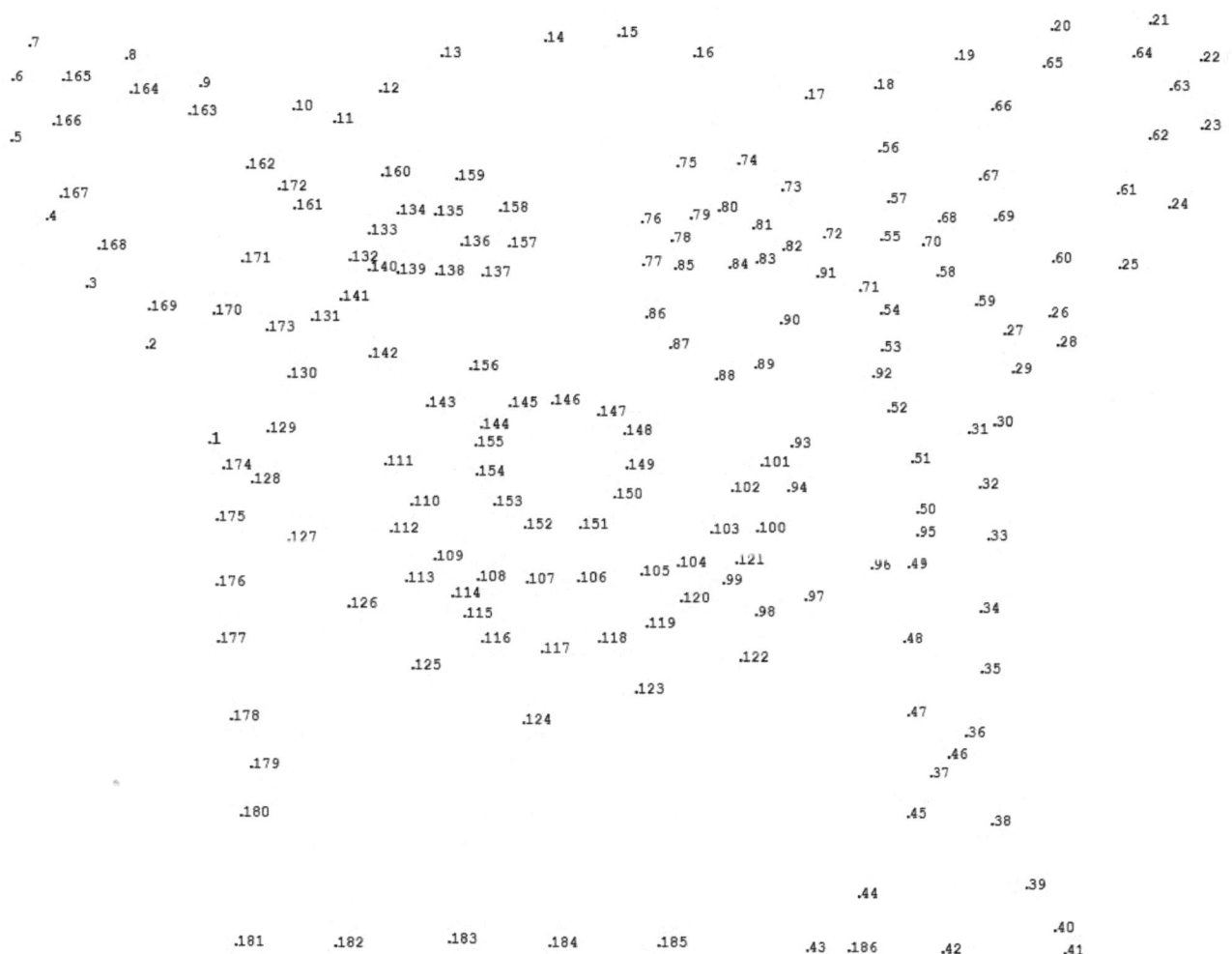

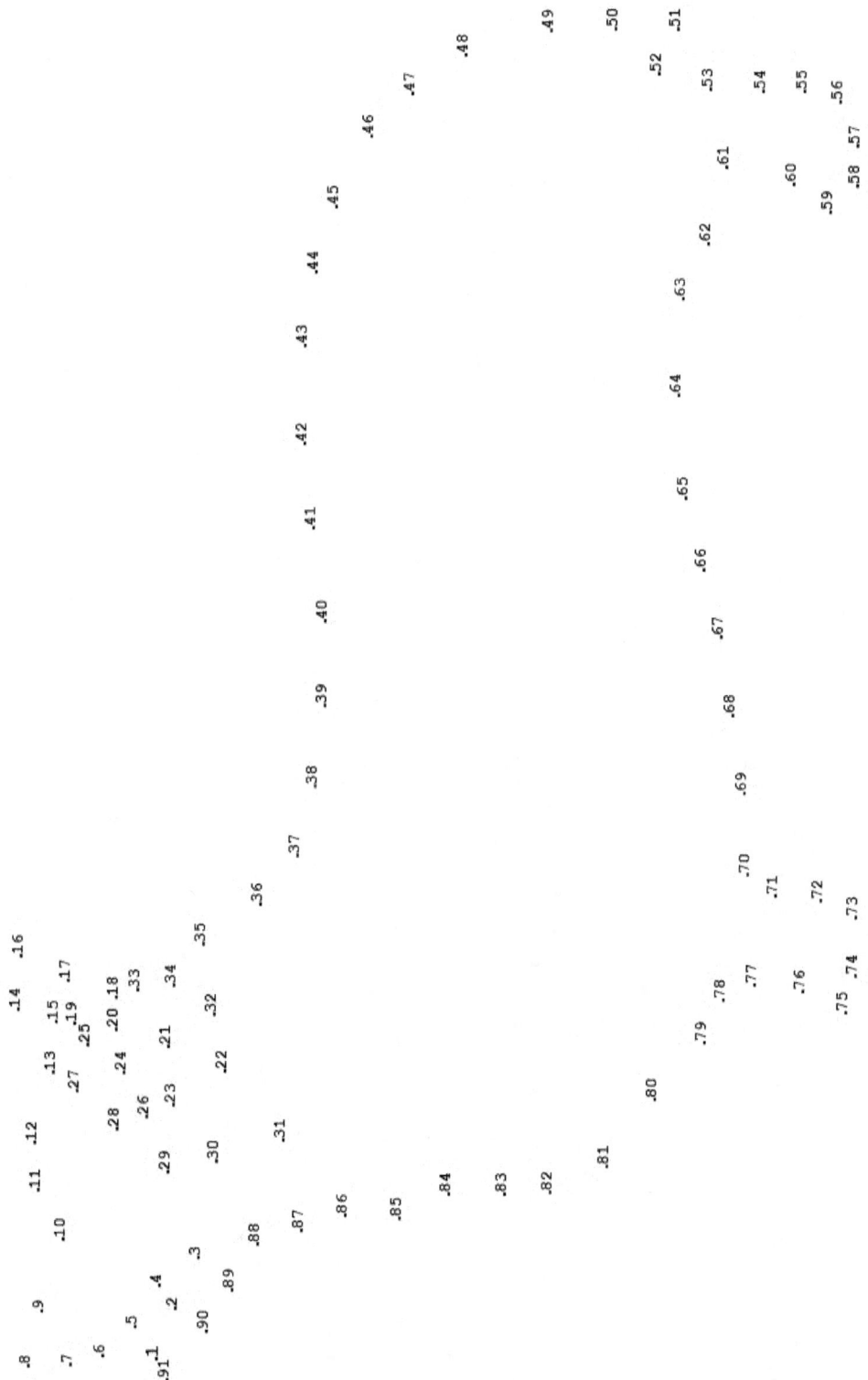

www.ingramcontent.com/pod-product-compliance
Lightning Source LLC
Chambersburg PA
CBHW080232180526
45158CB00010BA/3150